All My Braided Colours

Siùsaidh NicNèill

le dùrachd

Siùsaidh NicNèill.

SCOTTISH CONTEMPORARY POETS SERIES

SCOTTISH CULTURAL PRESS

First published 1996
by Scottish Cultural Press
PO Box 106, Aberdeen AB11 7ZE
Tel: 01224 583777
Fax: 01224 575337

British Library Cataloguing in Publication Data
A catalogue for this book is available from the British Library

ISBN: 1 898218 55 2

The publisher acknowledges subsidy from the Scottish Arts Council
towards the publication of this book

Printed and bound by
BPC-AUP Aberdeen Ltd.

Scottish Contemporary Poets Series

(for further details of this series please contact the publishers)

Contents

Questions of Reality

Siùsaidh NicNèill moved in 1988 from Skigersta on Lewis to the Isle of Skye; an unpopular move forced by economic necessity. Now, however, Camus Croise has become her home and it is from here that she works with ABU-tele, a Gaelic Broadcasting Independent Company, as a producer/director. She has worked in broadcasting for more than 20 years.

She has been published in several anthologies, Scottish and International, as well as magazines. *All My Braided Colours* is her first collection.

Acknowledgements

To Jay Ramsay for guiding me through the morass that passes for my mind and Val Gillies for giving me the confidence to take a leap into the void and Angus Peter Campbell for making sure there was a net below. And to Mairi Morrison for giving me my independence on the Apple Mac – to them all I give thanks.

'Murchadh', 'Home Again', 'A Tangible Memory' – *Siud an t-Eilean* (Acair, 1993).

'My Friend', 'The Sea Has a Purpose', 'Is there a Purpose?', 'Sad Boreraig of the Stones' – *Ffrwthyau* (Oak Tree Press, 1994).

'Confidence Tricks', 'Sgainneart' ('Wreck'), 'Sort of a Love Poem' – *Different Boundaries* (Smeddum Press, 1995).

'Wreck' – *Getting Lippy* (Democratic Left, Edinburgh, 1996).

STARTING POINTS

Camille

Don't touch me.
My body is sacred
and not for your hands.
Don't wake me.
My sleep, my dreams
must go undisturbed.
I don't want you.
You must undertstand.
I don't hate you
but I want to be alone.

Seanmhair (Grandmother)

The wind billows your shawl.

 Great black sail.

Talk from your pillow was
that you were

 frivolous.

Fringes on the blind whisper.
Always drawn
Against dark thoughts.

Keep the brightness within you.
Keep the laughter warm.
Let the fringes sing.

And forget the tongues
as long and sharp
as the memories of sin.

Their sin, a'sheanmhair.
Not yours.

Manhandling

If I held you in my hand
I could walk across the Kyle
And touch the head of Sgurr Alasdair
Without a wet foot.

If I held you in my hand
I could glide to Elgol
Ceilidh through the night
And never fail.

If I held you in my hand,
My dream, my reality,
I would clasp you tightly.
A prize too easily taken
 for granted.

Ferry

Between each sighing wave
Another story hides.

With each inconstancy
I cannot tell the lies
From the roar of the tide.

Behind the stern of every ship
Lies a wake of half truths.
Thrown to the tossing heads.
Left to be picked by seagulls.

CONVERSATIONS AND PORTRAITS

The Poet at his Reading

He shifts his foot
from plank to creaking plank.
His other foot is fixed
philosophically to the board,
and sonorously his voice
paces each well thought out word,
rising in an angelus
when time is called.

Time is taken to explain
the words written,
the passages grafted
onto his hybrid phrase tree.

They smile comprehendingly.
They applaud enthusiastically.
The words are so literally literary.

And still his foot winds its circle,
uncomfortably,
interminably.

(Words to be read in
not read out).

Even the faithful look bored,
(But never blank,
Never blank),
Full of concentration,
Rabid admiration,

Do they really understand,
these poor accepting fools,
what came from your mind
(never blank, never blank)
onto the vacuous white page?

As you shift your foot
from plank to creaking plank.

Catriona's Chronicle

The Manhattan skyline of '21
Heralded the entrance of the youthful bride.
Sixteen, secret, sleep with me.

> The minister says:
> Thou shalt not.

Sixteen, a wife in New York.

Raasay, rolling rumbling.
A sour welcome for the child.
'Wedded? A foreigner? On board?'

> The minister says:
> He can sort it out.

'You'll have no supper tonight.'

The brave new world of '26.
Paris throbs, dry, Bohemian streets.
Modigliani will die of drink.

> The patron says:
> All painters go that way.

Back home they're all on strike.

Berlin of '36, threatening, gloomy.
The hotel you'd newly met in will be bombed.
Laughing, singing, Jewish, lover. Hide him.

> Brecht says:
> He would write you a poem.

But for your origins, my Lady.

From war to war in '42,
You stood shoulder to chest with Knox.

The Royal Mile milled with your children.

 The minister says:
 You are redeemed.

But your own child does not live.

Without husband or child,
No life is left. Home by the island,
Paint and pain.

'This, my father was a good man.'

But even the minister does not say,
How he, your father,
Was first to clear his land
And plant the sheep.

Monuments are raised, churches saved.
'This is one of me – and my father.
A good man, hard man.

 The peasants say:
 He was generous.

I'll build another cairn to his undying memory –
or perhaps finish this portrait.'

At seventy, the childless mother
Considers it wise to end her days
And her painting on Uist.

 They have said:
 To the south Uist is flat.

And Catholic.

 The minister can say no more.

For Eric Blair

Our generation had no Spain,
no romantic fight to draw
the passions forth,
and commit us for life
to the Cause.

Bandolero Rosso, Bandolero Rosso.
We lifted our voices in fervent song
aching for a fight
that our minds had out-grown.

Immersed now in Highland comforts,
collectors of those things we despised,
how easily our youthful dreams are mislaid
when the bellow of suffering has died.

Bandolero Rosso, Bandolero Rosso.
We can only lift a chant for a Chile or Nicaragua
now that our sword is blunted
on the soggy edge of talk.

Sort of a Love Poem

Hi, how are you?
Nice to see you again? I think.
Oh, you're leaving?

For good?

(Now that you've let me
taste the wine again,
my lips sweet with the redness of it...

You're leaving?)

Well, if you ever find yourself
in these parts...
(keep on going)
Don't pass by...

(You led me to the riverbank
and touched my love...
my fingers tingled
as they tangled in your hair.)

That's fine then, good-bye.

Good-bye.

(And so, farewell then.
We had a frolic and a fuck.
And I will return
to the state of static contentment
from which you so cruelly
yanked me.)

A wistful smile is left.
What else could there have been.

Good-bye then.

At the Reading of the Book and Beyond

(the day of the funeral of 'Domhnull Beag an Taillear', Donald MacKay, Skigersta, December 1986)

1.

Stare into the chasm.
The flames licking
the belly of the peat.
Warmth and comfort.
Security and memories.
How can they think
of these dancers as
 Hell.

2.

Heads bowed.
Tears dried.
Ready for 'Job'.
The prayer drones on.
Sniffles are plugged.
Eyes glaze steadily
with expectations of
 Eternity.

3.

Our old man has gone
the last limping walk
from the village
with no women at his side.
We stood,
our legs nipping in the wind.
Screaming eyes flecked in the
 salt air.
The tide rising above
 bent shoulders.

Conor

We met in Mullingar
When the lights went out.
I sat regaling them with stories
You sat with a candle lighted for company.
In the dark my cigarette
Drew circles and spirals and faint
Celtic snakes in the air.
But I could see your eyes
And you were alone.
As was I.

While the thunder stormed outside
We met in Mullingar.

Murchadh

A'Mhurchaidh, the clouds
are scudding in fast.
It's a long walk to the meeting house
with the threat of rain.
Why bother tonight?
Your soul will last
another week. Perhaps.

But will your body hold out
until the last pictures of the psalm
drift out of sight
to meet the waves?

For peace of mind he drags his body past
the Co-op and the school-house.
The fear of pain
less than the fear of the might
of the Lord and His caste.
Another week. Perhaps.

But the years are too many on your frame
and the soaking you will take
will leave you nothing but
the thanks of the Lord
and a small patch in the clay.

Oran Gaoil

Bithidh gaol agam orts'
 gu bràth
 gu bràth
Ged a dh'fhàg mi do bheatha
Seasaidh mi na do chridhe chlachach
 gu bràth
 gu bràth.
Thug thu thairis leat mo sgrios,
 gun deasbad bhuams.
Thog sinn cus fhacal aig an àm ud

ach cha chuir mi ceum
a mach as do chridhe
 gu bràth
 gu bràth.
Thoir an aire ort fhein, a'ghraidh…

Love Song

I will love you
 for ever
 for ever
Though I have left your life
I will stand in your stony heart
 for ever
 for ever
You endured my desolation
 without discussion.
We had too many words as
 it was.
But I will never step
outside your heart
 ever
 not ever

Oran Bais

an urrainn dhut
 an t-àite seo lionadh
ma dh'fhàg e

chan eil e furasda
 aite
 mòr
 fuaim
 chiùin
 beatha
 bhais.

Song of Death

can you fill
 this place
if he is gone

it isn't easy
 a big
 place
 a gentle
 sound
 a dead
 life

A Tangible Memory

Your old blue jacket
still hangs behind the door.

Bobbles and fluff
and worn weaving
cling to the sleeves.

The cuffs sag sordidly,
elastic long left by the fences.

And I saw you last
by the peats,
your old blue jacket
hanging on the spade.

CIANALAS (HOMESICKNESS)

My Friend

My friend the Heron
Used to stand in the Creed.
I would walk there on quiet days
And we would talk.
He was a reserved sort,
My friend.
But good through
 and
 through.

I joined him one day
And stood on one leg.
I fell down.
But he didn't shake his head
Or show his disapproval.

That's my friend.

The Creed is a wooded area in Stornoway with a river running through.

The Sweet Scent of Memory

I

The smell of Fidgi and sweat;
a night of riot on a Parisian boulevard;
thick, black coffee in the 'Trois Magots' –
I found the third
in an underground gallery;
he sighed and asked me to come home
to the damp and garlic
I swept with the dust into the cavities.

II

The Joy of Jean Patou
and Collette and her beloved Jean Paul
in that same cafe,
same table,
same existential wine,
same endearing sophistications
and a Gnostics laugh,
barbarous under the gas lamp.

III

But Dior was of Dublin.
I can't think why.
A duty free treat
or O' Donoghues crush.
The Sherbournes memory
of Sebastian and Joyce
and prim tea in cracked china
and the sharp, sweet scent from a musty bottle,
lost like everything
at the Punchestown track.

IV

An unamerican odour,
Yves St. Laurent.
The only bottle I'd bought.
So unflowerlike,
just New York.
The canyons on 8th Avenue,
the first I tried
smelled of cannelloni
and lost Irish pride.

V

The gagging sweet breath
of cheap sprays and essential oils –
in remembrance of scrimping student days
and Guinness in Sandy Bells.
It pervaded the glands on your skin
and made you belong
to the West Port book shops
and under the bridge at Canongate,
just the wrong side
of the lavender tracks.

VI

L'Air du Temps
is anonymous on the wind.
All fluff and romance.
The reality smells
of neat alcohol,
late nights
and early mornings
in Macs' Bar, Stornoway.
A bubbling still
of booze and vomit.

VII

The true scent of memory, however,
can't be bought in Duty Free.
It's of Highland rose and iodine
from the tangle mass on the shore.
It's the smell that hits you
when you first open the door.
The unexpected rush of unemptied rubbish
and cat litter
and the unedited story
of a life written in these walls.

Home Again

Home again to the flat island
to see the horizontal washing
flapping maniacally.
The sharp north-easterly
springing the pegs
from the line
and the smoke coughing from the stack.

From the south west
it would blow back
to choke the firesiders.

Cloud

In the plate blue sky high clouds rest;
downy feathers from the breast
of a giant tern
and tomorrow – or after
the winds will come from the north east
and tear
the ridge tiles from the house.

An Dorchadas Meileabhaid

Ann an dorchadas meileabhaid is cùramach
tha mi crùbadh on smuain bhiorach
agus cha do leig mi cionta bhith
 tighinn nam amhran

An suathadh ciùin air do bheul
 mar a tha e'g eirigh le gaireachdaich,

agus do lamhan ruadh mar a tha iad
a' gabhail
 m'anail dhut fhein
neo a' gabhail pairt còmhla riums
 airson greiseag.

The Velvet Darkness

*In my velvet presbyterian darkness
I shrink from the probing thought
and do not allow guilt
 to enter my song.*

*The gentle touch of your mouth
 as it rises in laughter,*

*and your brown arms as they take
 my breath for your own*

*or to share with me
 for a while.*

Re In Carn Ate

I burn, I burn
with bitterness
(the stingy kind
that leaves your eyes
Red.
They burn).

Who cares
what you *think*
in here (tapping the temple)
the mind, the intellect
are part or parcel or such
 of the flesh
and it burns.

Only the soul
and what remains of the heart
has another
threepenny ride –

 as a buttercup

 or a starling

 or a President.

Latha Mor

I dare not meet you clothed in yellow
of the Bealtainn flower.
Or see the rose blush of clover
in the hollow of Latha Mor.

I prayed for mist to cover my head
and hide me from the gleaming eyes
who watched to see where I would fall.

But you, this place filled the space
of the hole left in my heart
by the longing to belong.

Why cry for a land where even the
sheep have analysts.

Where the Long Walk takes you to the edge.
Where grey is the only light on black.

But when I meet you clothed in yellow
with the smile of the sun and the laughter of the terns

I ache for you Latha Mor.

*Latha Mor – part of the village of Skigersta, Ness, on the north end of the
Isle of Lewis.*

Before I Knew

I was a Jew in Massada,
I crossed the barbed wire
and was a tin can kicked
in Gaza.

I was there when the heat
seared the fat
and the picks broke
the desert sand.

I was there when the scarfed men
closed the port
and the guns scarred
the Holy of Holies.

And when Kadish
was sung for you Israel,
my prayer was Shalom.

Weather Pattern

Mid-May nineteen ninety three;
the flaring snow makes it difficult to see
the bonny, bonny broom.
Bowed head, sadly, puzzled.
Fresh bloomed and shining
bathed in a false warmth
and hope.

The swallows are back from Africa,
swooping low,
scythes through green corn,
sadly, puzzled.

There's a little hole in the sky
we know
but can't see.
Can't pull our fingers through.
But believe in
sadly and very puzzled.

Because the Spring tide came over
the High Road
and the May trees in bloom
are flowered in snow.

Dark Side

I have seen the dark side
of man.
A black scarab of
ill fortune.
A sharp needle eye
that leers.
A lack of light in
his soul;
the spiritual void,
the material hammer.

Cat God

A fat figure of Bast,
inscrutably,
 unblinkingly,
records the antics of the passing
 birds.

Waiting,
 watchful
Buddha of the feline form.
The Gods have blessed
 your paws,
 your flittering tail.
Your amber eyes,

pricked with blackness
pierce the safety
they thought was theirs.
 Merciless.
 Wild.
And yet
you curl your warm body
around my leg.
You kneed my stomach,
your sleep as peaceful
as a flower

and my love for you.

Iona, West Beach on a Rainy Day

An old left shoe, lost overboard.
An expensive trainer it was once, too.
The knot still tied.
Where's the foot, I wonder?

A frog flattened by the road.
Arms and legs as they last flapped.
An Atlantean survivor
finally tattooed by rubber tread.

Rocks of red and bright pale green
finely etched by sand and weed.
The golden grains and dark, dark wrack
thrown up like a stallion's mane.

A final hard scramble up to *Dun I*
to reach a well on the roof of the soul.
Heather scratched and fenced in
at every turn –
 I retreat.

The Sea has a Purpose

Have you watched a wave
white head rising
roll
 and
roll
from miles out into the Atlantic,
with a purpose and vision
like the salmon she carries?

She has one end in mind.

But the relentless journey ends
fruitlessly battered off the cliffs.

Rejected.

But she finds a gap
 and
 rolls
on to kiss and caress the earth,
the silver sand and red ragged stones
and gently lays down to let her
brother and sisters wash over her,
now dead, head.

And goes back to start again.

QUESTIONS OF REALITY

Dreamtime

Many are the dreams and fantasies
(Oh stranger of my waking hours)
That miles have driven between loves.
I need only the misty recognition
Of your grudged smile
To satisfy the hunger.
Short lasted it is,
Brief and groping.

But forgetting to forget.

Come not in my sleeping
To disturb the reality of my distant love.

The Word

From beneath the senses
comes the word.

Turn the deep pit.

The clanging of hammers
hurts the rock
upon which
I build my thoughts.

I know the ninth wave
as naturally as the nine fold sigh
of the wind.
As the nine fold billow
of the flame.
As the nine fold furrow
on the field.

As the eight fold year
which marks the passage
of our lonely lives.

Life in a Single Dimension

Life in a single dimension
is a line.
This line curves and crawls
and makes the word.

The word is wyrd,
is fate
and asks the question.

The question is,
where to now?
As the line scrawls on.

The line forms the helix
that is time
and takes up no space.

(This space on the page
doesn't count.
That is secondary.)

And the helix
when doubled
is life itself.

And fate (the wyrd)
pulls the line
like thread through an eye.

The eye becomes earth
and the word becomes soul
Aether is that one dimension,
the starting point of all.

Snow Haiku

Driving through the driving
snow
each flake reflected
in my lights.

Blinded.

Love Ha Ha Haiku

All those women
thought they knew you.

Not quite.

They were wrong
and you're left alone.

Haiku Haiku

A scattering of haiku
ripe plums beneath the tree

or a slugs trail

Secret Haiku

I told you a secret.

But you lied

and radioed it
to the world.

St Colum Watches his Back (Derry '94)

Pretend normality
as the Foyle flows on,
and bristling Tin Cans are
as blindingly human
as the cream and blue of an Ulsterbus.

Kid yourself on
that nothing ever happens
on the narrow wynds
beneath the ancient wall;
the siege was done with
three hundred years ago.

Keep smiling on
when the traffic slows
on the high bridge
over the river
to watch the next
bold view
of a man
at the end of his tether.

Sad Boreraig of the Stones

I

Sad Boreraig of the stones
your one blind eye still weeps.
Your broken enclosures, fish box littered.
Open doors still welcome the visitor from the shore.

How could you know it would be like this?

II

Thrown up in a line
straight as soldiers rank,
the plastic boxes orange and
yellow from Lochinver.
And onion boxes of blue,
deep and intense as the Virgins' mantle,
washed from Spain to the
rocky, unsettled shore of Boreraig.

III

The spirits lie deep in each polythene piece.
Eternal and fixed as rocks,
imperishable as the mountains
and loud with fluorescent laughter.
Souls borne on the Gulf Stream
and through the Sound of Sleat
from Newfoundland's new found land
far from beggarly croft and shellfish midden.

IV

There is fear in this place,
sad Boreraig of the tumbled stones.
Where even the strength of your modesty
cannot cloak you from the fingers
scratching and scraping at your memory's song –
the lament of the ninth wave.

V

The fear is the fear of aloneness.
The fear that your spirit has returned
to find emptiness and sheep and the footprints
of soldiers.
Where once there was the peat flames warmth
and the smell of salted fish.
There is now no-one to remember that this old shoe
was a woman who wept for her drowned love,
or that broken creel was a father joyful
with the herring to feed his children.

VI

Only emptiness and sheep and the footprints
of soldiers
are left to hear the lament of the ninth wave
for sad Boreraig of the stones.

Boreraig – a village on the Suisinis peninsula, Isle of Skye, cleared of all inhabitants in the 1850s. The village is accessible only by boat or a six mile walk over the moor.

Is there a Purpose?

I
Is there a purpose to the land?

To let the sea caress it.

Is there a purpose to the moon?

To stop the waves in their optimism.

What is the purpose to the sea?

The sea's purpose is
to make us dream of infinity
in green and grey and white
as if we were the wave that
 kisses the sand

 but once.

II
Is there a purpose to the wind
that flattens the corn
and tears the ridge tiles from the roof?

Ask the crofter. He will know.

III
Is there a purpose to our life?

The purpose to our life is
not to sit back
and ask stupid questions

but stand and shout them to the wind
and feel the wind answer
calling them back
to the sea, the moon, the land.

Now

I love you
Now
And all the nows we share.
Yesterday,
Now
I was curious, tossed my head and laughed.
Now soon ends.
To-day,
Now
I sailed in the curragh of discovery.
Now journeys onward.
Tomorrow,
Now
Might find a final barrow
to bury my love in.

And Then

I said
I love you now
And all the nows
Joined to form
A rushing wave, crashing on the skerries.
And the nows became thens
And a thought became when and
What will I do with my nows now?

Steel Yourself

He said my eyes were misty grey;
soft as the morning light

on the head of Marsco
or the heron rising.

And now they are steel.

clank
clank

steel shutters down.

What made it so?
Brittle and hard.
Unrequited in love,
perhaps?
Or just a vacuum –
where love should be?

Gone the silver smile.
Now it's lined with lead.

clank
clank

White Buffalo Calls

A sunset more of molten gold
I have never seen before.
The sky layered in colours
brash to subtle.
A warm soft grey,
the shade of a tear.

I looked out over the Delaware
and saw the greatest plains
stretch out and along
West and North to the very edge

 of infinity.

And the white buffalo calf's head,
kissed by clouds,
reached out and bellowed –

'I have returned.'

*One of the seventh generation legends of
the Lakota – come true.*

Ghost Dancer

Where are you, my warrior?
does your naked soul
still wander coldly,
shivering between high tenements,
crying for the high canyons
of the sacred Black Hills?

Hold your bleeding red hand
upwards,
supplicating Father Sky.
Your Sun Dance scarred chest
proudly bathed in the ghostly light.
And when a feather from the hawks wing
settles on that dear green place
talk will be done,
your spirit will be clothed,
you will come home
and we will have lost nothing
but the joy of knowing
you lived among us for a hundred years.

Ghost Dancer.

For the spirit of the warrior whose Ghost Dance Shirt
currently resides in Kelvingrove museum and for which
the Wounded Knee Survivors Association is fighting to
repatriate.

Touching Custer

She gave me earrings,
the old woman with a smile like a desert rose,
porcupine quills and beads.
'You might like these,'
she said.
She who left the reservation
to nurse the wounded through the war,
carrying her Christianity quietly,
humbly.
As you might expect.
She handed me the gift
in remembrance of her grandfather,
who killed Longhair
at his Last Stand.
And the century melted
 before me
like a lament on the wind.

White Horses

When I was in Uffington
I stood in the eye,
threw my arms wide
and cried
'Today is a good day to fly'
and the horse came with me,
Pegasus and daughter of Daedalus
and white springing clouds.

On earth again
I limped wearily across the castle platform.
The floor of a shallow cauldron
and saw nothing but sheep.

But *they* saw me
as they busied themselves with their lives.
Selling cabbage,
cooking pork
and wondering –

who was that bare legged woman
dressed in royal purple?

I was their ghost.
Unaware of my effect
until I disappeared onto the Ridgeway.

Ego Sum

I am the lily of grace.

I am the song of joy.

I am the pearl of god.

I am of victorious heart.

I am the champion of life.

I am the name that I am.

Dreamtime II

Come and dream with me,
To the place where darkness
tastes of warmth and milk;
where light has the touch of angora
and smells of jasmine;
where the winds are violet
and the sea an aria;
where childhood is at an end
but the songs are just starting.

Come and dream with me
on a raft of angels kisses.

Conversations with a Sister

'You have an angel on your shoulder.'
She said.
'And the thumbprint of Jesus on your throat.

You are special.'
She said.
'And God protects those who love him.'

'When God created Man,'
I said,
'Was She only testing the market?

Or did She have some plan in mind,'
I pondered,
'that makes us girls a bit more special?'

'Who protects the blasphemous?'
She asked.
Her lips curved in a snarl.

'Why, the Goddess, of course,'
I replied.

And I still believe in angels.

Sgainneart

1.

Eisd ri gairm na gaoith
a cuipeadh an uidheam

 Sgreuchach.

Eisd ris an aiseann a stairneachadh
an aghaidh nan creagan geala

 Sgreadach.

Ca' bheil thu
mo leanabh lurach?

Nach do chaill mi thu fo na tuinn?

 Nach do chaill mi thu…

 Nach do chaill mi thu…

2.

Bha do chuairt mu dheireadh murtraidh

phàisg a measg lamhan somalta.
Ach thainig thu air ais gu mathair tais

bha a chorp a sgriosadh air an oir
 bainnse
agus bha a spioraid a sgriosadh

 air an sgeir fhulangais.

Wreck

1.

Listen to the cry of the wind
whipping in the rigging

 Screaming.

Listen to the ribs crashing
against white rocks

 Shrieking.

Where are you
my bonny baby?

Did I lose you beneath the waves?

 Did I lose you...

 Did I lose you...

2.

Your final journey was warm

wrapped in gentle arms.
But you came back to a cold spirited
 mother
whose body was wrecked on the
 coast of marriage
and whose spirit was wrecked

 on the skerry of suffering.

Mentor, Teacher, Guide

(To Angus MacDonald, Uig, Isle of Lewis)

You opened the book
like a mighty chasm.

Deep, dark, inviting.

I threw my head back,
my arms open wide

and dived in – welcoming.

I gambolled among them,
O'Casey, MacDiarmid, MacCaig.

Too young to be drowning.

I loved Bold, adored Muir,
worshipped at the feet of those
who enticed me through

the mass of prose
and proselytising verse.

But you were the beacon,
my patron saint of poets.

You found me – wanting.

And were ready to give
the colour and riches

you had been gathering
as a gift from the islands

 to me

knowing, unknowing.

Song of Insanity

Swaying uncontrollably
 on the pavement edge of sanity,
The poor little city creatures
 plunge head on,
Ready to dive into
 the inconstant stream.

There is no loyalty here
 and no betrayal –
If you know how
 to read the signs.

There is no danger here
 teetering across the chasm.
No chance
 of the earth quaking.

Your own safety chord
 Song of Life.
 Song of Joy
will keep you tethered
 on the right path.

When the left path calls
 and beckons through the mire,
How easy it would be
 to travel –
 to abrogate responsibility

 or

to take over the asylum.

Accept.

Carry it around with you
 on the other right path.
The one few can see
 and fewer know of.

The path that bear and wolf
 and blind men walk.
The path where concrete
 returns to sand
and bricks to clay.

The path that lies
 on the other side of sanity
Where sanity equals destruction
 of mind and spirit

And the Holy Fool
 is not yet king.

Identity Crisis

The crocuses are coming.
The crocuses are coming.

Little stiletto spikes
cutting through the sod.

Battered by wind,
abused by dogs

but determined to cry

We are Crocii.

The Plums are Growing Thick

The plums are growing thick.
The trees are sagging beneath the weight
And green, oh green grows this glen o.

The moor is vast and flat.
The silence snags on the straight road
And the stones, oh the stones they sing o hu o.

The rose is opening her face.
Her smile is shining brighter
But the clouds, oh the clouds are glowering down o hu o.

The war is a raging fire.
The drought lays waste the forest
And the child, oh the child cries a dreadful song
 o ho bhan hu o.

The governments lie sleeping.
The soldiers march on through o
And this day, oh this day is the last
 Where we will laugh o hu o.

The last notes drift down the bank.
A chord crashes through the bushes o
And the child sings a dreadful song
 of the plums that once fell off a tree o.

Once there were plums on a tree...

Dreamtime III

Sleeping a trouble sleep.
Tossing the cover back
 until they are twisted round

My tired body.

Dreaming of a man on a tightrope.
Same grey suit, same staid tie.
 His mobile 'phone ringing

Does not break his stride.

Confidence, he cries!
As the tightrope swinging,
 each solid footstep defies

the pull to certain destruction.

Does he reach the end
of his rope, the grey man?
And who is it that is calling
 as he shudders uneasily?

And in my sleep
 a sensation of
 falling.

Confidence Tricks

Stand with your toes over the edge
$\qquad\qquad\qquad\qquad$ of the cliff.
Face the wind from the North West
$\qquad\qquad\qquad\qquad$ and *lean*.

Far out.
$\qquad\qquad$ Farther.
$\qquad\qquad\qquad\qquad$ Farther still.

A childhood game reflected in grown up fancies.
Foolhardiness, or bravery, or confidence?

Form the question in your mind and
a) ask it silently within
b) give it to a friend
c) stand up and declare it aloud.

'It's all so subjective, my dears.
Are they the poets, the soothsayers and seers
or do they form the greater sum
of ego, sweaty nights and tears?'

Ego, blood, sweat and tears
but greater than these, by far,
is fear.

Fear of flying off the cliff,
stretching out to reach your life.
Fear of someone saying no;
or worse,
a terse maybe, perhaps, another day.

Confidence plays such tricks,
a roller coaster of sickening rides.
'Down into the deepest depths I peered'
whilst waving from the mountain top.

Despair and elation in equal amounts
fighting the panic of that one little step
of hanging your toes over the edge
with your face to the wind from the North West
and *leaning* your whole self
Far out.
 Farther.

 Farther still
until somebody finally says: 'Yes.'

Dreamtime IV (Wayland's Smithy)

Shoe my horse with iron
and I will leave you silver.

Cross this stone in sunlight
and I will draw a river.

Sing this song in wind verse
and I will paint a whisper.

Lay on this earth beside me
and I will stay forever.